1 ~ www.ForestAcademy.org ~ 1

Visual Special Effects

~

Film, TV, & Video

~

By:
David K. Ewen, M.Ed.

ISBN-13: 978-1492927952
ISBN-10: 1492927953

Copyright (c) 2013, Ewen Prime Company
All Rights Reserved

Introduction

Visual Special Effects for video, film, and TV are put in place as part of a post-production process. The physical video is worked on after filming. This book and course serve as a solid foundation to understand how visual special effects work. In our discussion, when the word "video" is used, we are referring any video content seen on TV, film, on the web, Netflix, Amazon, DVD, etc. The word "video" will be an all inclusive word for any type of visual content.

Graphics has to do making something different than how it was recorded in real life. The best example is a TV weather reporter standing in front of a map with graphics. The reporter is standing in front of a blank green wall. Computer software is used to make the green wall look like a map with the reporter standing in front of it. The image of the reporter in front of the green wall is laid on top of the image of the map. Then the green wall is made invisible or transparent so that you can see the map behind the reporter.

In this book and course we will have you become familiar and using green screen technology that you can work with at zero cost. Higher capabilities have a small cost via purchasing more advance software.

The goal of giving you the free options get you started with exploring the technology seen on TV with weather reporters and maps.

3 ~ www.ForestAcademy.org ~ 3

This book and course provides an introductory demonstration of how green screen special effects work. After a basic demonstration is introduced, then the next level of complexity is added to show more capability for green screen. Additional resources and ways to find them online are provided so that you can utilize the tools that best fit your goals.

The approach described here is intended to start off initially as basic to give an understanding and clear picture of how green screen special effects work. Use this as the knowledge foundation stepping stone toward your true goals.

The idea was to use freely available resources. For higher levels of capabilities, resources are available, but at a reasonable cost.

My initial experience with video green screen special effects was with a web based online tool called "Jay Cut". It is no longer available. Video special effects come at a cost, usually under $100. Still animation effects that we will describe are free. We discuss that here to provide you the ability to research, be educated, and discover what working with green screen video production is all about. Following that, the discussion turns to resources that come well under $100.

Chroma Key

Chroma Key is the technical term associated with the visual green screen effects. It is seen commonly for weather forecast broadcasts. You see a reporter in front of a map. In real life the reporter is in front of a bright fluorescent green screen. The image of the reporter in front of the green screen is overlayed on top of a weather map or weather reporting graphic. The green is then removed leaving only the reporter overlayed on top of the weather map or graphic. The fluorescent green was "keyed" out or made transparent.

The visual effect is two images with one layered on top of another. The top layer has a subject with a surrounding area of bright fluorescent green. That green color is keyed out or made transparent so that the background shows where the green use to be.

This capability is done with still images for example a person overlayed on scenery. It is also done in video for example a TV weather reporter in front of a map with video graphics.

Most commonly is a background that is still and has no motion. This is seen in a television talk studio set or a movie scene for example a science fiction movie scene on a spaceship.

Our Example

For simplicity and to more easily demonstrate the technique and free software to make a video with special effects, we will create a very basic animation using the Chroma Key green screen special effects.

BACKGROUND

Background

Our background will be a still image where the subject will be placed in front. Backgrounds should have nice colors and a variety of colors. Backgrounds of an inside scene is more realistic as it would match the subject that most likely would be recorded inside in front of a green screen. A background of a beach would awkward if it is obvious that the subject's lighting appears indoors due to recording inside in front of a green screen.

There are two places to get free backgrounds. One is done by taking a picture. The other is online. If you use online, search for rooms found in a home, office, hotel. The rooms in a home, office, or hotel seem to work best. Make sure that the angle of the view is at eye level and would match the subject being recorded. Search criteria that would fit best are:

- "Hotel Lobby"
- "Office Lobby"
- "Living Room"

You may also try exploring a search for "free virtual tv sets"

Props for Virtual Set

You can modify your set with props. Let's say your virtual set is a living room and you wanted to add a chair. You can get a chair online by searching for a *.PNG file of a chair that has the outside of the chair transparent so when it is overlaid on your virtual set, it will look like the chair is part of your set. You can resize the chair just like any image. The way you search for a chair with a transparent background is by searching for "chair, PNG". Search by entering the word followed by a comma and then the necessary file time PNG. You may have to download a few chairs to try on your virtual set to ensure the lighting and colors match.

Create Virtual Set From Scratch

You can create a virtual set from scratch. Everything you need can come from Google.com or Bing.com.

The first thing new need is a wall that shows the floor. Search for "***Wall and Floor Background***" to get the back wall and the floor. You can also try searching for "***Empty Room***". Make this image the full background of a Google Presentation (Google Drive) or PowerPoint slide. Add props in the form of PNG files to be included on your set. The props are overlaid on top of the image of the wall and floor representing the empty room.

Search for the following..

- Wall and Floor Background (use this as the primary background for your set)
- Stairs, PNG (place on the side of the set)
- Plant, PNG (to place on tables)
- Door, PNG
- Bookcase, PNG
- Chair, PNG
- Table, PNG
- Fireplace, PNG
- Window, PNG (resize an image to go behind the window frame)

The props can be added as an image inserted and resized on the slide of your Google Presentation or PowerPoint. The background is your image for "Wall and Floor Background" that fills the entire slide and serves at the background of your Google Presentation or PowerPoint.

SUBJECT

Remove Green

Removing the green from an image uses Chroma Key technology. Chroma means color and Key refers to keying out a color. Keying out a color means to make it transparent or invisible. Here we will be keying out the green back-drop by making it transparent or invisible.

There is free web-based online software to make the fluorescent green transparent for images. It is called Luna Pic. The website is **www.LunaPic.com** When you enter that website, it brings you to: **http://www130.lunapic.com/editor/**

It is very intuitive to use.

- Step 1 upload by clicking upload button
- Step 2 click Edit & select option "transparent"
- Step 3 Click the image color you want to make transparent

You'll notice the option at the top referring to "fuzz". The default is 5%. You may want to increase that if not all of the green background becomes transparent. A green fabric backdrop may not become fully transparent due to folds and creases resulting in shadows that changes the color pigment. An increased fuzz allows for a blend of pigment to become transparent making the background of the subject see-through.

When complete, download the subject image to your computer. Pictures with transparent surroundings are GIF or PNG files. If you uploaded a *.JPG file, then the resulting edited file with a transparency added, will be a *.GIF or *.PNG file.

You'll discover that Luna Pic has other editing features available.

Remove Green

Removing the green from an image uses Chroma Key technology. Chroma means color and Key refers to keying out a color. Keying out a color means to make it transparent or invisible. Here we will be keying out the green back-drop by making it transparent or invisible.

There is free web-based online software to make the fluorescent green transparent for images. It is called Luna Pic. The website is **www.LunaPic.com** When you enter that website, it brings you to: **http://www130.lunapic.com/editor/**

It is very intuitive to use.

- Step 1 upload by clicking upload button
- Step 2 click Edit & select option "transparent"
- Step 3 Click the image color you want to make transparent

You'll notice the option at the top referring to "fuzz". The default is 5%. You may want to increase that if not all of the green background becomes transparent. A green fabric backdrop may not become fully transparent due to folds and creases resulting in shadows that changes the color pigment. An increased fuzz allows for a blend of pigment to become transparent making the background of the subject see-through.

When complete, download the subject image to your computer. Pictures with transparent surroundings are GIF or PNG files. If you uploaded a *.JPG file, then the resulting edited file with a transparency added, will be a *.GIF or *.PNG file.

You'll discover that Luna Pic has other editing features available.

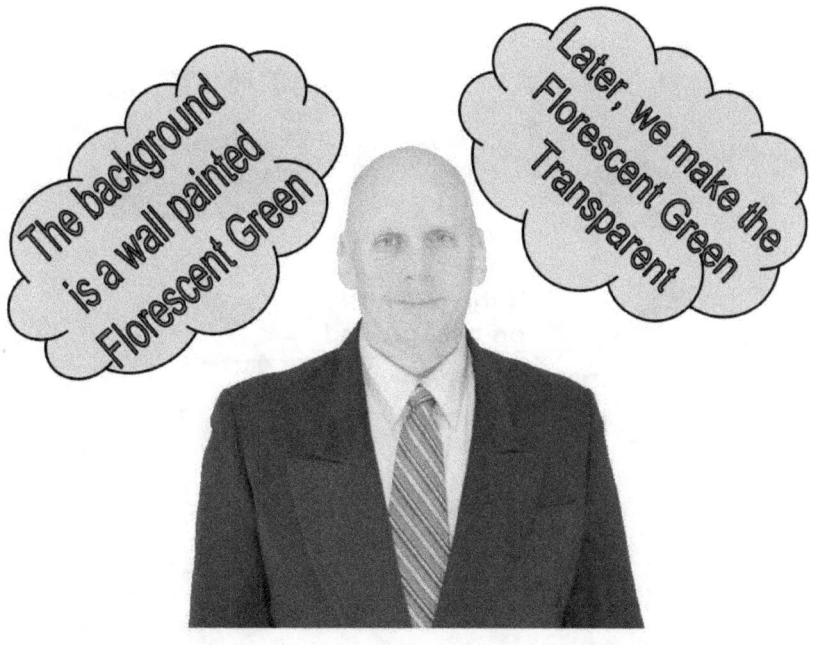

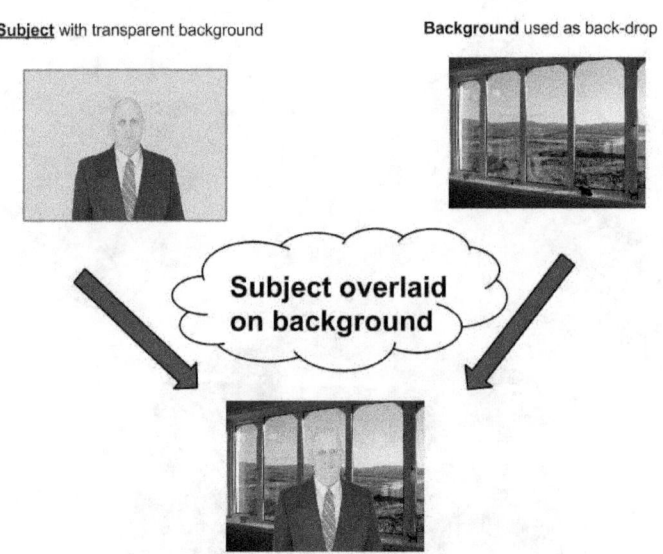

Other Free Chroma Key Software

www.online-image-editor.com

Learn how to use the "transparency" feature by going to:

www.online-image-editor.com/**help/transparency**

Another Chroma Key Software Example

Download the Movavi software by going to

www.movavi.com

Learn about the green screen chroma key effect by going to:

www.movavi.com/**support/how-to/how-to-use-chromakey-effect.html**

Learn more by going to

www.movavi.com/**support/how-to/**

17 ~ www.ForestAcademy.org ~ 17

Chroma Key Software Resources

The topics discussed here is a start. Create a short simple animated video using a subject with a transparent surrounding overlaid on a background. When you have succeeded, you will have a solid foundation of the green screen special effects.

Your subject can be in motion with a green screen background. You'll need special video editing software supporting a subject in video with a transparent surrounding overlaid on a background. **Tube Tape** provides all the tools needed for green screen filming technology. Here are is a collection of tools.

- Tube Tape www.TubeTape.com
- Green Screen Wizard www.greenscreenwizard.com
- 123 Video Magic www.123videomagic.com/
- VideoPad Video Editor http://video.nchsoftware.com/videopad

The VideoPad Video Editor Software can be found in many places online by searching for "**VideoPad Video Editor**" It has a free download.

Search for other video editors online. Search for "Chroma Key Video Editor"

ANIMATED MOTION

Animation & Storyboard

We have talked about placing a subject with transparent surrounding in front of a background. Animated motion is done by changing the subject image position or using alternate image. An example of using an alternate image is a change in hand position, facial expression, etc.

The independent images are slides. The slides can be created by PowerPoint or a similar tool in Google Drive called Presentation. Each slide is downloaded as a "picture" in the form of a JPG file. The JPG files are then uploaded to a video editor, for example One True Media (www.OneTrueMedia.com). The slides play for 3 seconds before transitioning to the next slide for another 3 seconds and then on to the next slide. The transition effect between slides is a dissolve. The background is consistent and the subject is what changes. With incremental movements of the subjects from one slide to the next simulates a very basic animation. This animation gives good practice in working with basic chroma key technology and development of a movie storyboard.

If you use a video editor to combine slides and MP3 audio, you can create a video to go on YouTube or a show to be aired on your Local Public Cable Access TV channel.

By creating a storyboard in the form of a movie will provide the best proposal vehicle to pitch a movie.

The video editor can have sound added by uploading a MP3 file. You can create audio recording for free by downloading Audacity from **http://sourceforge.audacity.com/**

I have done talk show animation with the audio coming from my radio talk show. My radio show episodes are stored as a podcast after airing and can be downloaded as an MP3 file. The resulting video is then distributed to Local Public Cable Access TV channels in a few towns. This way the radio show becomes a TV show.

20 ~ **www.ForestAcademy.org** ~ 20

Subject

For animation of a person that will be placed in front of a green wall or screen, you will be taking pictures of someone at various angles and hand motions. The subject will be photographed in front of a bright fluorescent green wall or screen.

Frames For Animation

For the purposes of illustration and simplifying the discussion of special effects, let's use an example of a subject walking across from one end of a room to the other. We need three things.

- Subject
- Background
- Frames

To create frames, I use the Presentation from Google Drive. It simulates PowerPoint. With your Google ID (you can create one if you don't have one), you can access Google Drive by going to http://Drive.Google.com. It's free and web based. You can also use PowerPoint.

Create a presentation or powerpoint. Set the background of a Living Room. Insert the subject with the transparent background as an image on the slide. The result is a subject in the living room. Duplicate that slide and on the new slide and move the subject slightly. Duplicate that second slide and on the third slide and move the subject slightly again. Duplicate the current slide to create a new slide. On the new slide move the subject slightly. The first slide will have the subject on one side of the living room. The last slide will have the subject on the other side of the living room.

Let's say you've made 10 or 20 slides for that motion. Download each individual slide as a *.JPG file. You may want to rename them to keep them organized and in order.

The next step is to place them in order for a video. Later you can add sound like music or yourself talking.

Motion of Subject

Your presentation or PowerPoint will have several slides that will have the position of the subject in different locations. Going from one slide to the next, you'll have the impression that the subject is moving from one location to another. The slides will be combined into a video with a dissolve transition between slides to give it a basic animation of movement.

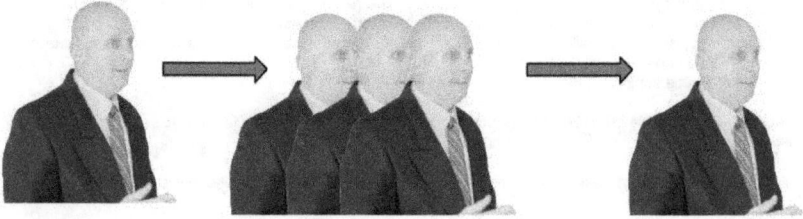

Animated Motion Video

I use a web based video editing software for storage, saving space, and consistency. It is called "One True Media". It is found at **www.OneTrueMedia.com** You can use this tool to serve as the cloud storage of all of your videos and movies. Register with and ID and password.

My other books, classes, and videos talk in more detail about the use of One True Media. I'll give a broad overview here.

One True Media is a web based video editing software that allows you to mix clips, stills, and audio to make a video. There are complex features that are available.

For the purposes of our current discussion, we will discuss combining the still image frames by putting them in sequence to make an animated motion.

Let's say you have twenty frames that when sequenced together gives the appearance of moving from one side of a living room to the other. When you select "Create A New Video" after logging into **www.OneTrueMedia.com**, you can upload your twenty frames (*.JPG) files in order.

By selecting "Edit Video" you have the option of selecting music or uploading your own audio or music file. The audio content needs to be MP3.

If you want to create your own audio content, you can use free audio recording and editing software from **http://audacity.sourceforge.net/**. My other books, classes, and videos talk in more detail about the use of "Audacity" as a sound editing tool.

24 ~ www.ForestAcademy.org ~ 24

Audio

Sound For Animation

We have spent a lot of time talking about the visual special effects for your video. What about the audio? In animation, audio is recorded separately. With motion video recording, the audio is recorded at the same time. The recording of the animation can be made in a variety of ways.

(1) The audio of an online radio show or podcast can be used as the audio for video. I take my talk shows on **www.BlogTalkRadio.com** and use them as my video talk show that I post on YouTube and for television on Cable Access TV. My radio talk show courses talk about the use of Blog Talk Radio. The links to my show can be downloaded by adding the suffix *.MP3 to the link and then right clicking on the resulting image to download the file as an MP3. Learn more by going to my radio talk show courses and books.

(2) You can record audio to match the slides by recording a screencast of you Google Presentation or PowerPoint by using SCREENR found at **www.SCREENR.com** For free, you can record segmenta up to five minutes at a time. The segments are downloaded as MP4 files and then uploaded to your account on One True Media (www.OneTrueMedia.com) to be combined with final edits.

(3) For greater control and formal audio editing capabilities, you can use the free Audacity software to download. It is found at **http://audacity.sourceforge.net** Learn more by going to my music production courses and books.

ADDITIONAL RESOURCES

More Free Web-Based Photo Editing

There are other free web-based photo editing software.

- http://fotoflexer.com
- http://pixlr.com/editor
- http://www.ribbet.com

Find more by doing a web search using "free web based photo editing software"

Other Web-Based Online Video Editors

There are other online web based video editors that are free.

- http://www.wevideo.com
- http://www.magisto.com
- http://www.loopster.com
- http://www.pixorial.com
- http://www.videotoolbox.com

You'll notice that some of these website have corresponding apps for iOS, Android, Windows smart-phones.

Creating Motion Backgrounds

You can extract a motion background that you find on YouTube. Enter the link on keepvid.com and download. You can clip a segment that works for you.

You can also record your own video background such as a beach scene with waves or moving clouds in the sky.

You can also look for stock media at:

- www.pond5.com
- www.revostock.com
- www.unlimitedstockmedia.com

Search online for stock media by searching for "stock media"

Use the motion backgrounds along with Chroma Key software so that your subject recorded in front of a green screen can be overlaid on your background. The software that can be used are:

- Tube Tape www.TubeTape.com
- Green Screen Wizard www.greenscreenwizard.com
- 123 Video Magic www.123videomagic.com/
- VideoPad Video Editor http://video.nchsoftware.com/videopad

The free backgrounds are motionless and images you can download from Google.com and Bing.com

Conclusion & Summary

Chroma Key

Chroma Key is the technical term associated with the visual green screen effects. It is seen commonly for weather forecast broadcasts. You see a reporter in front of a map. In real life the reporter is in front of a bright fluorescent green screen. The image of the reporter in front of the green screen is overlayed on top of a weather map or weather reporting graphic. The green is then removed leaving only the reporter overlayed on top of the weather map or graphic. The fluorescent green was "keyed" out or made transparent.

The visual effect is two images with one layered on top of another. The top layer has a subject with a surrounding area of bright fluorescent green. That green color is keyed out or made transparent so that the background shows where the green use to be.

This capability is done with still images for example a person overlayed on scenery. It is also done in video for example a TV weather reporter in front of a map with video graphics.

Most commonly is a background that is still and has no motion. This is seen in a television talk studio set or a movie scene for example a science fiction movie scene on a spaceship.

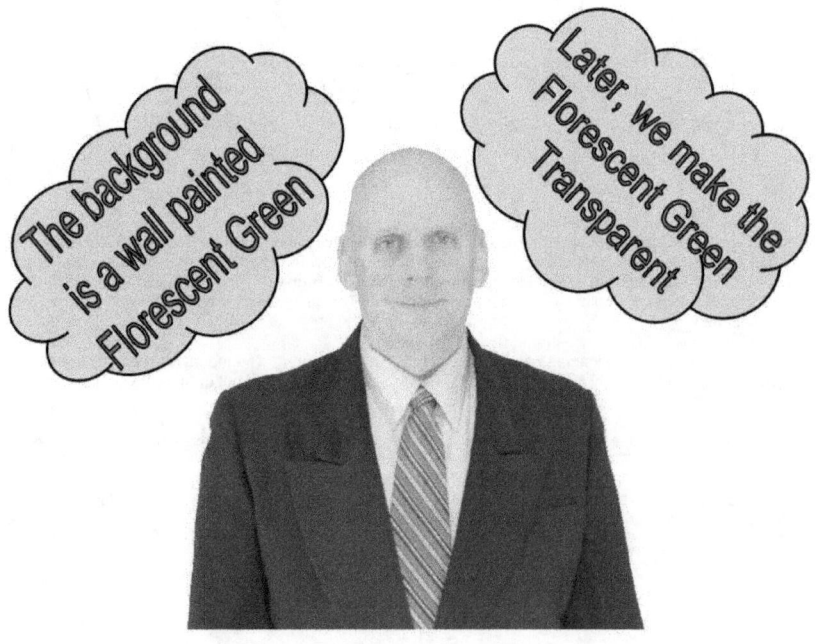

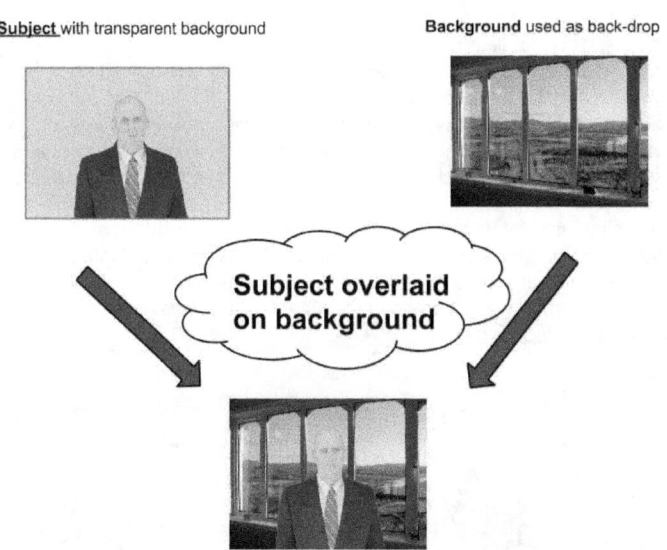

Motion of Subject

The image of the subject will have the green back ground removed using Chroma Key software (example: LunaPic) to make the green background transparent or invisible. After the green background of the subject is made transparent, the subject image can be overlaid in front of or on top of the background scene. Movement is simulated by having multiple duplicate frames with the only difference between frames is the placement of the subject. For example multiple frames can show the subject moving incrementally by the placement of the subject on each frame. The transition between frames in the video will be a dissolve. The multiple frames will be combined to make a simple animated video.

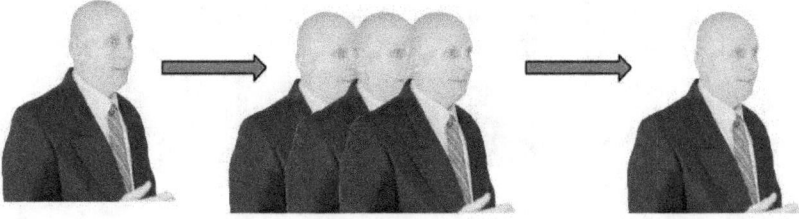

Thank You

~

David K. Ewen, M.Ed.

Visual Special Effects For Video, Film, and TV

David K. Ewen, M.Ed.

www.ingramcontent.com/pod-product-compliance
Lightning Source LLC
Chambersburg PA
CBHW051226170526
45166CB00005B/2055